READY TO PAINT

Roses in Watercolour

Janet Whittle

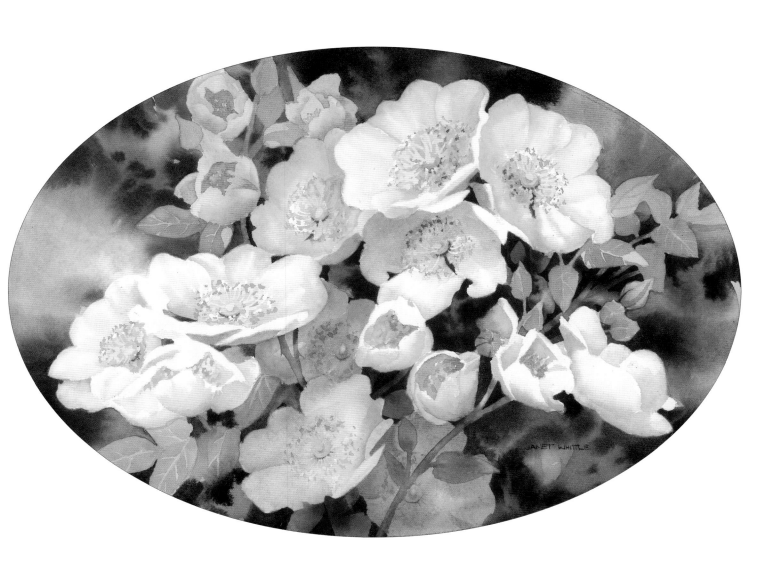

SEARCH PRESS

First published in Great Britain 2011

Search Press Limited
Wellwood, North Farm Road,
Tunbridge Wells, Kent TN2 3DR

Reprinted 2012

Text copyright © Janet Whittle, 2011

Photographs by Roddy Paine Photographic Studios

Photographs and design copyright © Search Press Ltd, 2011

ISBN: 978-1-84448-635-9

The Publishers and author can accept no responsibility for any
consequences arising from the information, advice or instructions given
in this publication.

Readers are permitted to reproduce any of the tracings or paintings
in this book for their personal use, or for the purposes of selling
for charity, free of charge and without the prior permission of the
Publishers. Any use of the tracings or paintings for commercial
purposes is not permitted without the prior permission of
the Publishers.

Suppliers
If you have any difficulty obtaining any of the materials and equipment
mentioned in this book, please visit the Search Press website:
www.searchpress.com

You are invited to visit the author's website at
www.janetwhittle.co.uk

Publisher's note
All the step-by-step photographs in this book feature the author,
Janet Whittle, demonstrating watercolour painting techniques.
No models have been used.

**Please note that when removing the perforated sheets of tracing paper
from the book, score them first, then carefully pull out each sheet.**

Printed in China

Dedication
To my son Duncan, with love always.

Acknowledgements
My thanks to Edd Ralph, editor, for watching my paint
dry and making copious notes, and to Gavin Sawyer
for photographing said paint. You were great fun to
work with, not to mention solicitous for my welfare
and stoically listening to my choice of music.

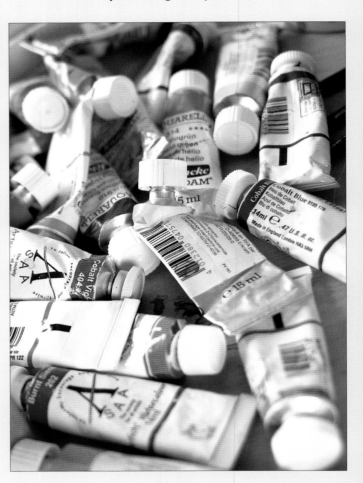

Page 1
Dog Roses – *Rosa Canina*
36 x 25.5cm (14¼ x 10in)

An unusual oval composition sets off these dog roses beautifully.

Opposite
White Iceberg *and* Pink Favourite
21 x 32.5 (8¼ x 12¾in) and *21 x 32.5 (8¼ x 12¾in)*

*Note the tonal contrast between the dark background and the much
lighter flowerheads on these paired paintings. People often find a
combination of matching paintings an attractive feature.*

Contents

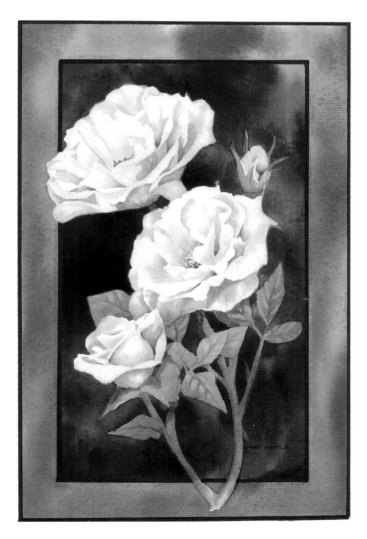

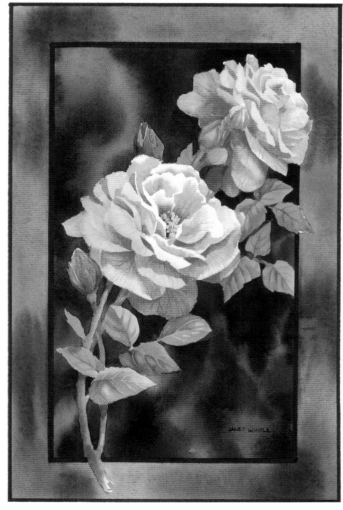

Introduction

Roses are very much a favourite flower of mine. The variety is enormous, from a simple wild Dog Rose to an exquisite, fully-blown Tea Rose, we are spoilt for choice – especially with regard to colour, which I love. The paintings in this book are designed to give inspiration for you to begin painting without being overwhelmed. Six tracings are included, five of which are demonstrated with step-by-step instructions to give you different approaches, colour combinations and ideas to practise for your own paintings.

These paintings are all in watercolour, and even if I were to do them again, they would not be identical. For this reason, there is no need to worry about following too closely, as long as you understand the techniques used and feel more confident about doing your own painting. I paint mainly from reference photographs, as I love to capture the moment with sunshine and shadows. In the early stages, I may use up to six photographs to compose a painting, but then I let go of my reference to create mood and feeling by using colours and tonal values that are not in the original to make my own interpretation of the scene. As any artist will tell you, nature rarely provides the perfect composition, either with flowers or landscapes, so your imagination can be your most valuable asset. Use it to improve your style and do not cling too tightly to photographs or they will limit your approach. In turn, this can make your painting too tight and restricted.

I tend to begin by using free-flowing wet-in-wet washes, then paint negative shapes and flowers within the background to give depth and interest, but although the composition is prepared beforehand, I often make changes as ideas come to me, or simply because watercolour does not always behave as you want it to! Some of my best work has been a result of these 'happy accidents', and this will also be the case for your work.

Six tracings are included: one for each of the projects, and a bonus tracing for the picture shown to the right. Do have a go, and I sincerely hope that this book answers some of your questions and encourages you on your journey through painting.

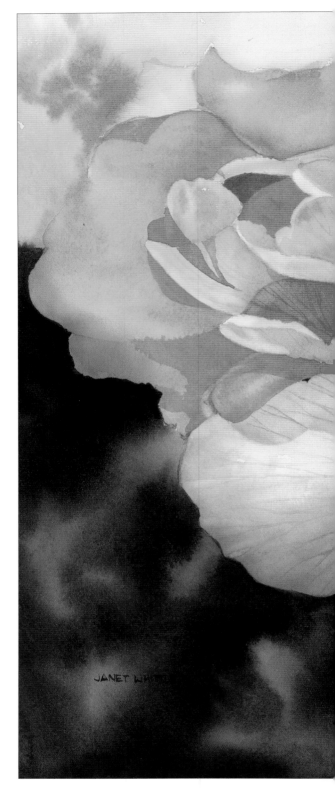

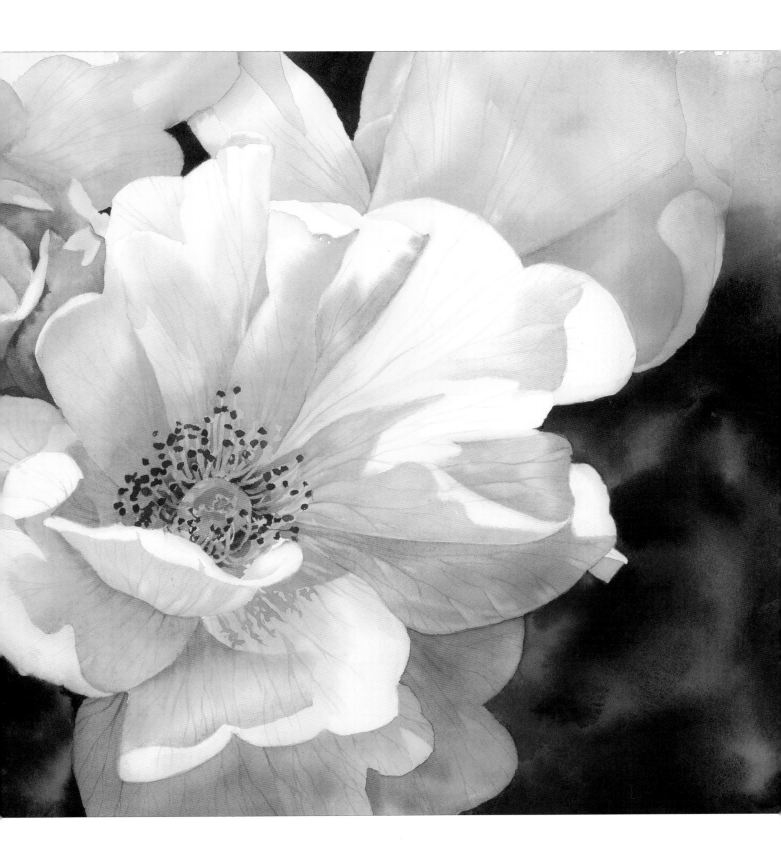

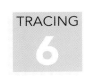

Maigold

53.5 x 36 (21 x 14¼in)

*This painting has two washes in the background. When painting
the second, I allowed part of the first wash to glow through in the
same way as the Maigold demonstration on page 30.*

Materials

Paints

Watercolour paints are available in tubes and pans, and I mostly use tube paints. They are also available in two qualities – artists' quality and students' quality. I always use artists' colours as they remain workable for longer.

If you have a combination of tubes and pans you will need to top up your pans with tubes when you are putting in a background, as you will need fresh, moist paint for mixing the quantity and richness of colour for working wet-in-wet.

I often try out new colours, but always use transparent colours for glazing. Using staining or opaque paints for these stages will deaden the colour underneath and lose the vibrancy that watercolour can give.

The watercolours used in this book are: cobalt blue, opera rose, Winsor violet, May green, helio green, Paris blue, quinacridone gold, indanthrene blue, aureolin, brilliant red violet, perylene maroon, phthalo turquoise, Winsor red, brilliant blue violet, sap green, helio turquoise and viridian.

A selection of watercolour paints in tubes.

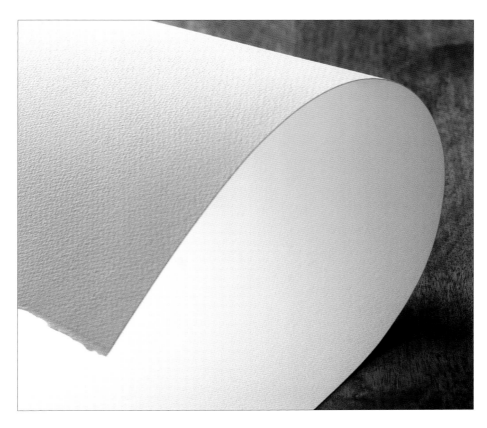

Paper

Watercolour papers come in a variety of finishes, such as Rough (a heavily-textured paper), Hot-pressed (a very smooth paper) and Not, which is short for 'not hot-pressed', and has a texture somewhere in between Rough and Hot-pressed.

I use Arches 300gsm (140lb) Not paper because it is adaptable and suitable for all the techniques that I use when painting.

300gsm (140lb) Not paper, suitable for all the projects in this book.

Brushes

I use the Da Vinci Maestro range of brushes to apply paint, and a small acrylic flat brush to lift out areas. You should feel free to use whichever brushes you prefer.

The following round brushes are used in this book: size 20, size 8, size 7, size 6, size 4, size 1.

In addition, I use a 5mm (¼in) flat and a size 1 rigger.

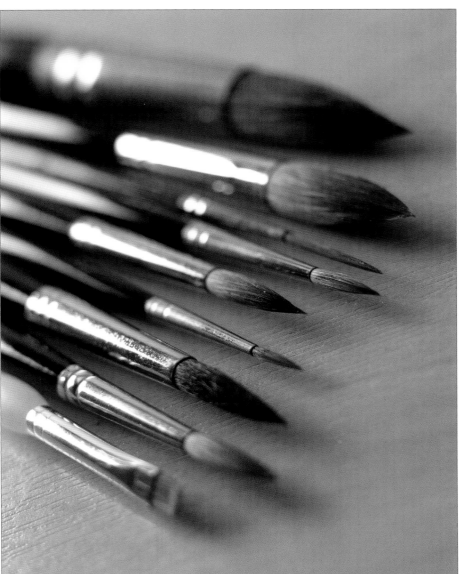

A selection of the brushes used in this book.

Other materials

Paper stretcher This is a board with clamps that is used to stretch wet watercolour paper to prevent it from cockling.

Reference photographs These are invaluable for you to check colours and areas of highlighting and shading when painting.

Spray bottle A spray bottle produces a fine mist, which is fantastic for re-wetting areas without disturbing the paint underneath.

Kitchen paper A supply of kitchen paper is necessary to dry your brushes.

Palette Try to find a palette with large wells, so that you can mix plenty of paint at once.

Pencil and **eraser** These items are used to transfer the sketch from the tracing paper to your watercolour paper.

Pipette This tool is very useful for transferring clean water to your palette to dilute paint.

Metal ruler and **pen** A felt-tip pen is used with the metal ruler to create strong borders.

Water pots Use two large water pots: one to rinse your brushes and one that you keep clean to prepare your paints.

Masking fluid and **old brush** I use masking fluid extensively to preserve highlights in my paintings. Because masking fluid can build up and damage your brushes, use an old brush.

Pair of compasses These are used in order to draw an accurate circle around the background of the Red Roses project on pages 24–29.

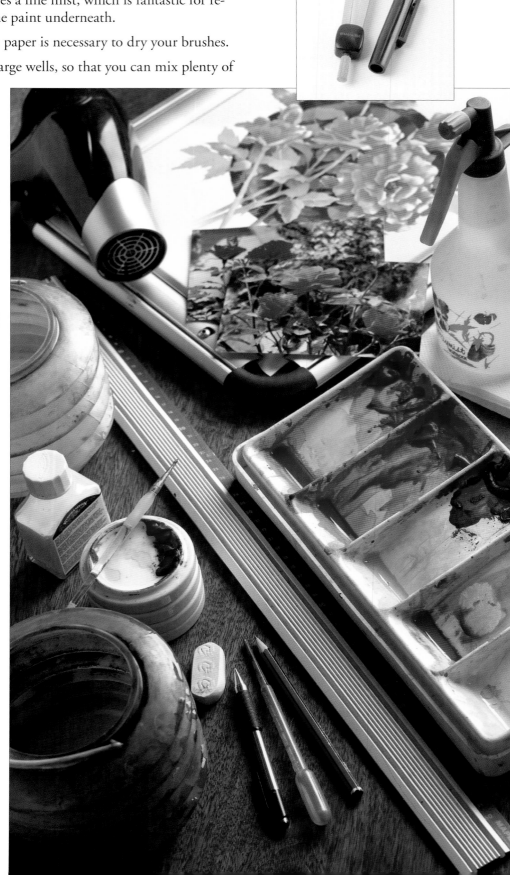

Clockwise from top left: hairdryer, paper stretcher, reference photographs, spray bottle, kitchen paper, plastic palette, metal ruler, pencil, pipette, fine felt-tip pen, eraser, collapsible water pot, ceramic palette, old brush, masking fluid. The inset shows a pair of compasses and a felt-tip pen.

Transferring the image

Tracings are provided at the front of this book for all the demonstration paintings. Follow the steps shown below to transfer the images on to watercolour paper. You can reuse each tracing several times so you can use the same basic image to produce two quite different paintings. Extract the tracing you wish to use from the front of the book and follow the instructions below to transfer the image to your watercolour paper. I have used a ballpoint pen to transfer the image, but a burnishing tool would also work.

1 Place your tracing face down on some scrap paper. Go over the lines on the back using a soft pencil (4B or 6B.)

2 Place the tracing face up on top of the watercolour paper. Use a ballpoint pen to go over the lines to transfer the image.

3 As you work, regularly lift up the tracing, ensuring the image is being satisfactorily transferred. When the transfer is complete, remove the tracing and you are ready to paint.

Pink Roses

With its flowerheads emerging from the framed and vibrant background, this is a slightly unusual composition for you to try. The framed background is enough for you to practise the technique of blending different colours together wet-in-wet and enjoying the effect it creates. Because watercolour paints dry lighter than they appear when applied, always work slightly brighter than you want the finished result.

You will need

300gsm (140lb) Not watercolour paper, 38 x 56cm (15 x 22in)

Colours: May green, aureolin, Winsor violet, opera rose, brilliant red violet, perylene maroon, quinacridone gold, helio green

Brushes: size 7 round, size 6 round, 5mm (¼in) flat, size 4 round, size 8 round

Masking fluid and old brush

Eraser and ruler

Fine felt-tip pen: permanent black

Kitchen paper

Paper stretcher

HB pencil

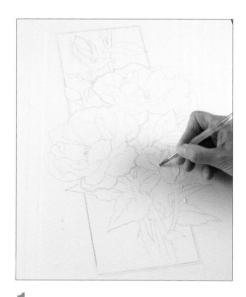

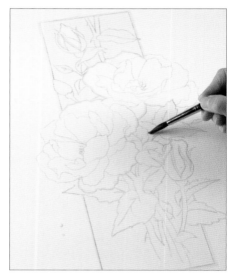

1 Transfer the image following the instructions on page 9, then wet the paper before securing it in your paper stretcher. Allow to dry. Use an old paintbrush to apply masking fluid in continuous lines inside the pencil lines of the flowers and buds, and also around the border. Make sure a sufficient amount of masking fluid is applied in each area inside the line, and allow to dry.

2 Prepare your palette with the following colours: May green, aureolin, Winsor violet and opera rose. Use a size 7 round and clean water to wet the background from the edges of the border up to the masking fluid lines on the flowers.

Tip

Tilt the paper against the light to catch the reflections and check there are no dry patches.

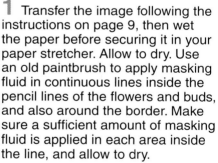

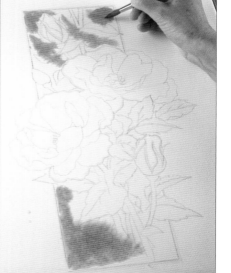

3 Use the size 7 round to drop opera rose into the wet background at the top and bottom left.

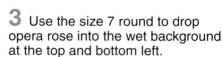

4 Drop in May green wet-in-wet over the leaves and stems, then add areas of aureolin to vary the colour in the background.

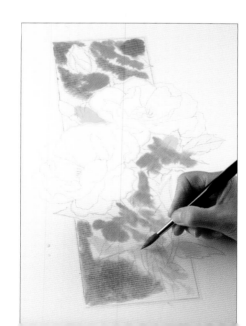

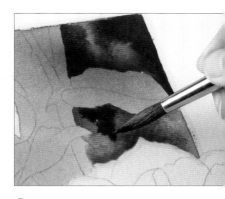

5 While the paper is still wet, drop in Winsor violet. Tilt the board, encouraging the colours to bleed into one another and flow up to the edges of the border.

6 Use a clean, damp brush to gently absorb any gathered beads of excess paint.

7 Still using the size 7 round, wet the stamen area in the centres of the open flowers with clean water, then drop in aureolin.

8 Switch to the size 6 round and dampen the background area at the top right. Drop in some opera rose and work in Winsor violet wet-in-wet.

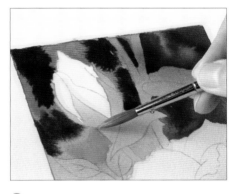

9 Being careful to avoid the foreground elements, repeat the process on the upper left.

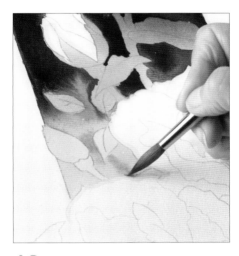

10 Develop the background on the upper left by adding May green and aureolin wet-in-wet. Tilt the board to blend the colours.

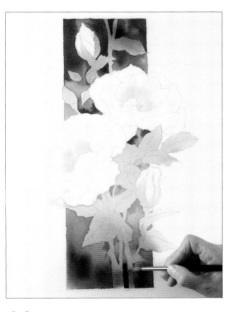

11 Continue working down the painting, adding May green, opera rose and Winsor violet in carefully, using the tip of the brush to paint between stems, leaves and other foreground elements.

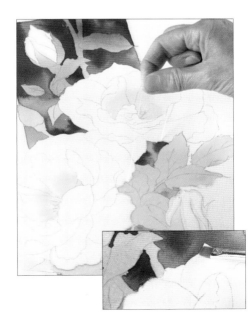

12 Allow the painting to dry completely, then remove the masking fluid from the flowers, leaving it on the edges of the background border. Switch to the 5mm (¼in) flat and dampen it. With small, controlled scrubbing movements, soften the paint at the edges of the petals to give a more natural edge (see inset).

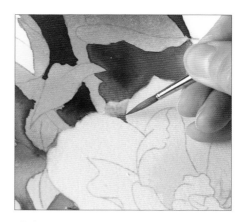

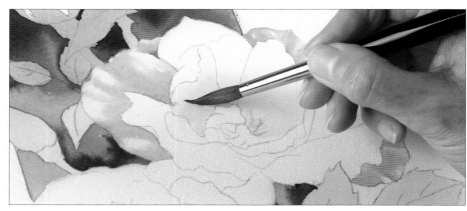

13 Wet the rearmost petal on the upper flower with a size 4 round, then drop in opera rose. Add brilliant red violet in wet-in-wet to the recesses.

14 Work the rest of the petals at the back, as these allow you to work out the tonal value of the petals in front. Once dry, use the size 8 round to wet and paint individual petals with the same colours to establish an initial coat.

 Tip

Working individual non-adjacent petals means that you can work faster without worrying about colours blending between petals. By the time you finish the last non-adjacent petal, the first set is likely to be dry, so you can paint the remainder.

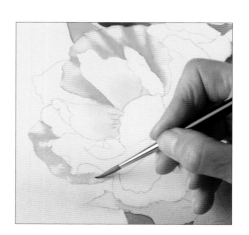

15 While the petals on the right-hand flower dry, begin to work the left-hand flower in the same way, drawing the paint in from the edges to get light-toned edges and deeper recesses. Leave some clean areas for the colour to bleed into, to serve as highlights as shown.

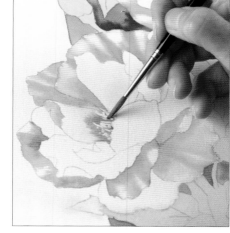

16 Once you have finished the outer petals, wet the stamen area on the left-hand flower and glaze it with opera rose and brilliant red violet.

17 Paint the remaining petals on both flowers, then paint the buds with the same colours and techniques. Allow the painting to dry completely.

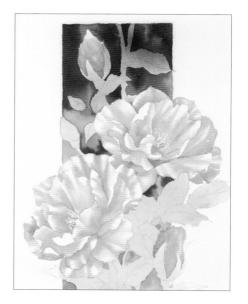

18 Use an eraser to knock back the pencil lines and remove the masking fluid on the border.

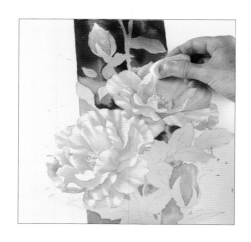

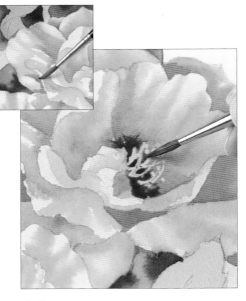

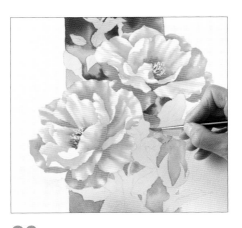

19 Begin to deepen the tones on the right-hand flower by wetting the petals and applying a glaze of opera rose in the shaded areas and recesses with a size 4 round (see inset). Add perylene maroon to the mix for the deepest shades, such as right in the centre of the flower.

20 Paint the remaining petals on the left-hand flower, then glaze the petals on the right-hand flower in the same way.

21 Using a mix of quinacridone gold and helio green, carefully develop the leaf on the right, bringing out the veining and highlights with negative painting.

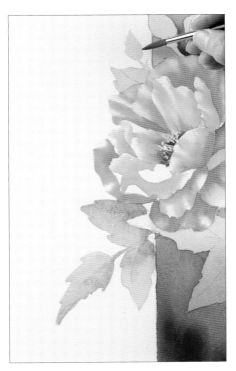

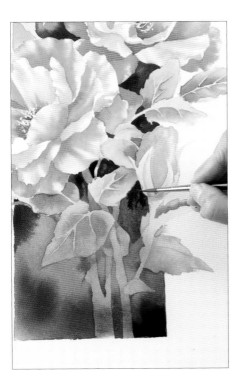

22 Continue using negative painting to develop the leaves by the upper rose, using the deepest tones for the deepest folds, recesses and shadows.

23 Sketch in a few extra leaves on the left with an HB pencil, then use the size 6 round with a dilute mix of Winsor violet and opera rose to suggest their silhouettes. Mix quinacridone gold with helio green, and drop it in wet-in-wet to vary.

24 Use the size 6 with the purple and green mixes to develop the rest of the foreground foliage with negative painting.

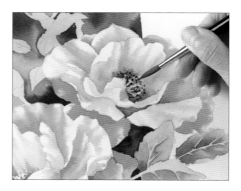

25 Knock back the pencil lines and remove the remaining masking fluid from the stamens using the eraser. Use the size 4 round to apply pure aureolin to glaze the stamens, then stipple on touches of a perylene maroon and Winsor violet mix.

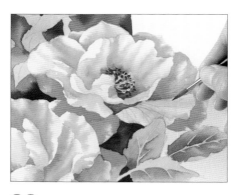

26 Still using the size 4 round, draw fine veins of pure opera rose down the petals, working from the centre of the flowers to the edges.

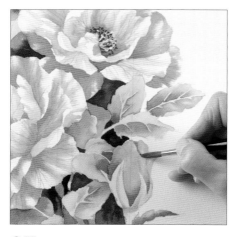

27 Keep the veins very fine and very faint as you work the remaining petals on both flowers, then use the same colours to add some modelling to the buds.

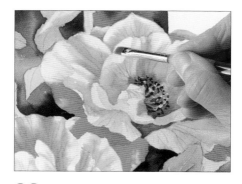

28 Soften any hard edges on the petals and leaves with clean water and the 5mm (¼in) flat.

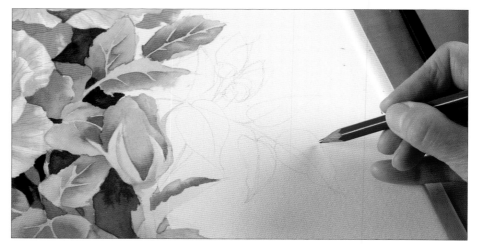

29 Use an HB pencil to sketch in some additional leaves on the right.

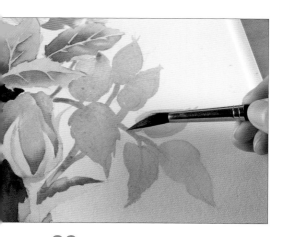

30 Switch to the size 8 round and use dilute brilliant red violet to paint in the silhouettes.

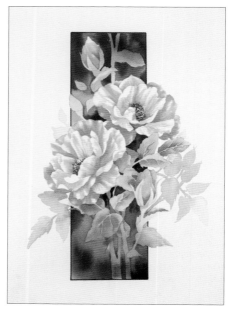

31 Allow to dry completely, then use a ruler and felt-tip pen to draw a border around the background box, leaving gaps where the foreground painting overlaps it.

Opposite

The finished painting, reduced in size.

14

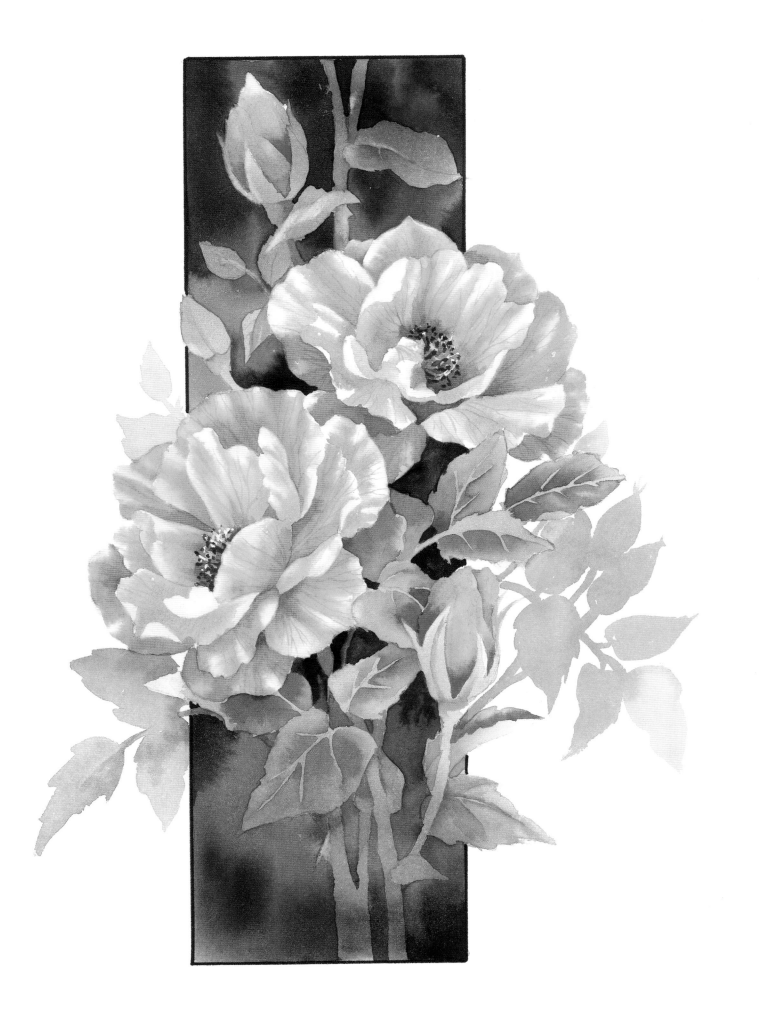

Yellow Climber

The trellis in the background brings out some of the focal roses, making them stand out without overworking them. Yellow can soon look grey, so I have used aureolin and quinacridone gold for the rose petals, adding a touch of opera rose for the deeper glazes. Both are transparent colours, so you can use them without risking the yellow becoming muddy.

You will need

300gsm (140lb) Not watercolour paper, 56 x 38cm (22 x 15in)

Colours: May green, aureolin, Winsor violet, quinacridone gold, viridian, indanthrene blue, opera rose, perylene maroon, sap green, helio green, helio turquoise

Brushes: size 8 round, size 6 round, 5mm (¼in) flat, size 7 round, size 4 round, size 1 rigger

Masking fluid and old brush

Eraser

Kitchen paper

Paper stretcher

Tip

Pour a little masking fluid into the lid and apply it directly from here, as it makes it easier to judge how much is on your brush.

Tip

Stippling is a dotting action. Use the tip of the brush to help get small, clean dots.

1 Transfer the image as described on page 9, then wet your paper and put it in the paper stretcher. Allow to dry, then use an old brush to apply masking fluid inside the pencil lines on the edges of the flowers to isolate them. Mask the stamen area with a stippling action.

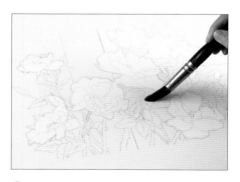

2 Prepare the following colours: May green, aureolin, Winsor violet and quinacridone gold. Once the masking fluid is dry, use a size 8 round to wet the paper to the edges, keeping the rose flowers dry, but working right up to the masking fluid.

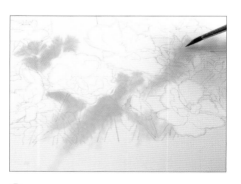

3 Still using the size 8 round, apply dilute May green over the stems and leaves loosely.

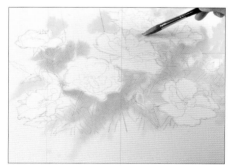

4 Drop in aureolin over the same areas wet-in-wet.

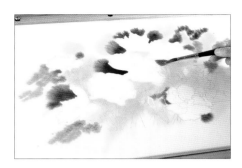

5 Working quickly, add dark areas of dilute Winsor violet and quinacridone gold as shown.

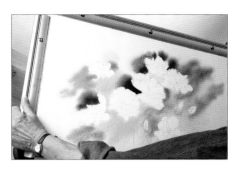

6 Pick up and tilt the board to encourage the colours to blend.

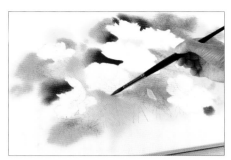

7 Reinforce the foliage areas with more May green and tilt the board again.

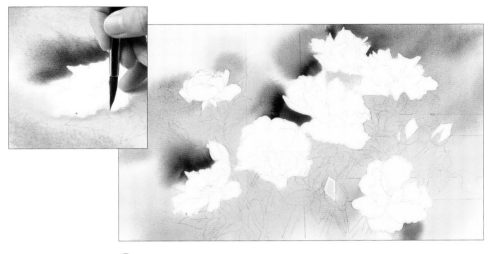

8 Use a clean, dry size 6 brush to absorb beads of excess paint (see inset), then leave the board flat to dry.

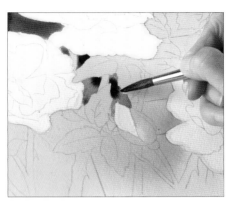

9 Using the size 8 round, make a mix of quinacridone gold and viridian. Starting from the centre, wet the smaller gaps between the stems and leaves and drop in the mix before adding indanthrene blue wet-into-wet.

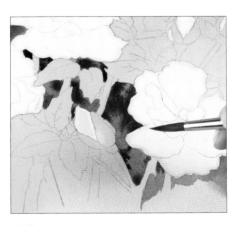

10 Vary the colour in the background by adding Winsor violet wet-in-wet, drawing it out and using the point of the brush to draw it around the stems and other foreground details.

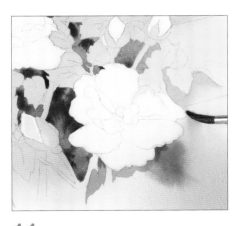

11 Continue developing the background areas on the right-hand side in the same way. When you reach an area without a border, such as at the edge of the painting, simply use clean water to bleed the colour away to the edge.

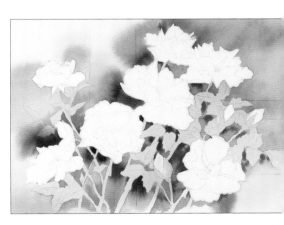

12 Once the right-hand side is complete, develop the rest of the background, working outwards from the centre in small sections.

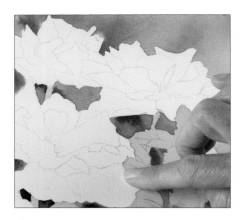

13 Remove all of the masking fluid, except on the stamens, using a clean finger.

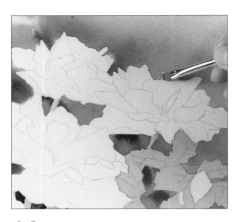

14 Soften the edges of the petals with clean water and a gentle scrubbing motion with the 5mm (¼in) flat.

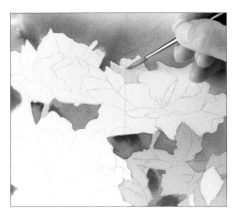

15 Using the size 7 round, wet the petals at the back of the top-right flower, then drop in aureolin with the size 4 round. Blend it away to white paper on the edges.

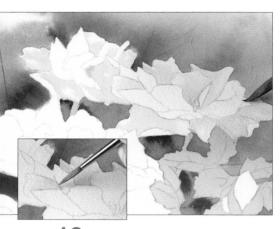

16 On the top roses, drop aureolin into the other petals where they emerge from the centre (see inset) then blend the colour away. Next, drop in quinacridone gold wet-in-wet to create the darkest shades. This creates contrast with the edges of petals in the front.

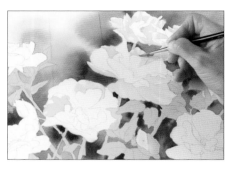

17 As the petals on the top flowers dry, begin to work the central flowers in the same way. Work on non-adjacent petals to avoid the wet paint bleeding into nearby wet areas.

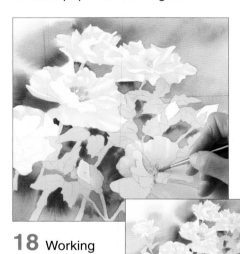

18 Working wet-in-wet, drop in quinacridone gold for shadows and around the stamens. Continue until all of the petals across the painting have been shaded (see inset).

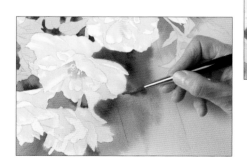

19 Turn the painting so the image is upside-down and dampen the trellis with clean water and the size 7 round. Drop in quinacridone gold.

20 Draw the paint towards you (see inset), then drop in Winsor violet and indanthrene blue wet-in-wet. Tilt the board to blend the colours and then place it back the right way up.

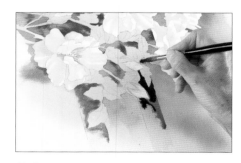

21 Use the same colours and techniques to paint the horizontal parts of the trellis, turning the painting just ninety degrees before dropping in the paint as shown.

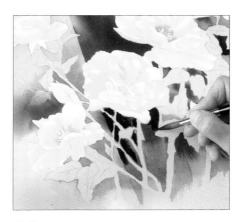

22 When working the parts of the trellis seen through the rose, keep the colours strong and dark, and use the point of the brush to keep the paint out of the foreground areas.

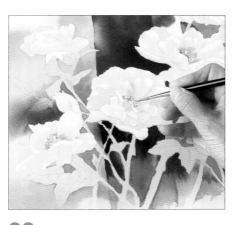

23 Mix quinacridone gold with opera rose and stipple it into the centres of the open roses using the size 4 round brush.

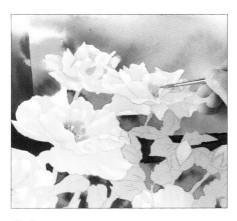

24 Prepare a mix of aureolin and opera rose. Wet the individual petals of the roses at the top of the painting and drop in a touch of the mix to add shading and create contrasting tones with the edges of the other petals.

25 Using the size 6 round to wet the petals and a size 4 to apply the colour, work down the other flowers one by one, adding the aureolin and opera rose mix to develop the tone. Stipple a mix of perylene maroon and Winsor violet into the centre of the focal flower.

26 Lift out the stems where the background colour has encroached, using clean water and the 5mm (¼in) flat brush.

27 Make a mix of sap green and quinacridone gold, wet the stems and drop in the mix on the left-hand sides. Vary the hue with touches of opera rose.

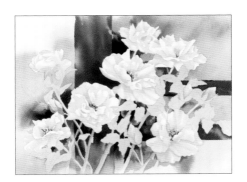

28 Develop the darks across the rest of the background, applying viridian wet-on-dry with the point of the size 4 round, then dropping in indanthrene blue.

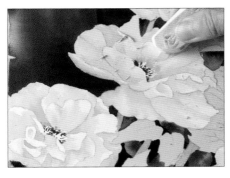

29 Remove the remaining masking fluid from the stamens and knock back the pencils lines from the whole painting using an eraser.

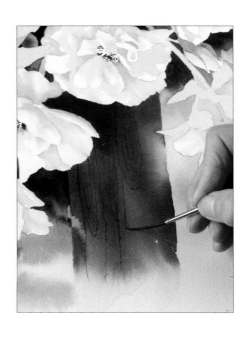

30 Switch to the rigger brush and turn the painting through one-hundred-and-eighty degrees. Use a mix of quinacridone gold and Winsor violet to paint the grain on the trellis upright. Draw the brush towards you to create long vertical strokes and loops.

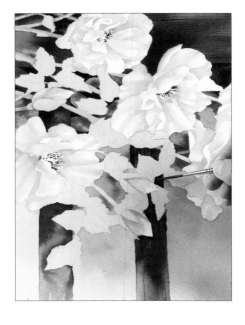

31 Turn the painting ninety degrees clockwise and use the same mix and brush to paint the horizontal parts of the trellis.

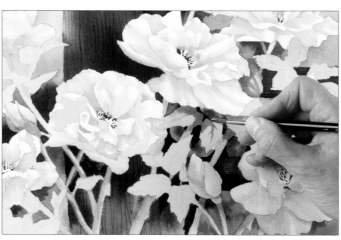

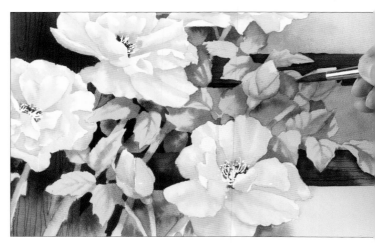

32 Switch to the size 4 round and make a dark green mix of viridian and quinacridone gold. Wet the leaves beneath the open roses one by one and apply the green mix to shade and model.

33 Repeat over the rest of the leaves across the painting, then shade the stems and buds with the same mix.

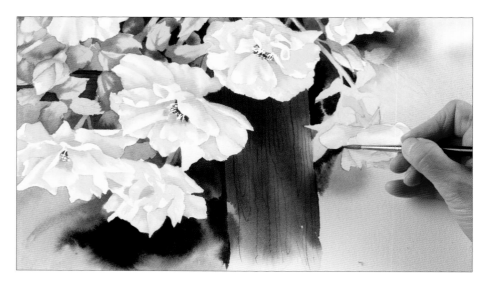

34 Turn the painting so the image is upside-down, then wet the areas by the top roses. Use a size 4 round brush to drop indanthrene blue into the gaps in the foliage to strengthen the tonal contrast between the light flowers and the dark background.

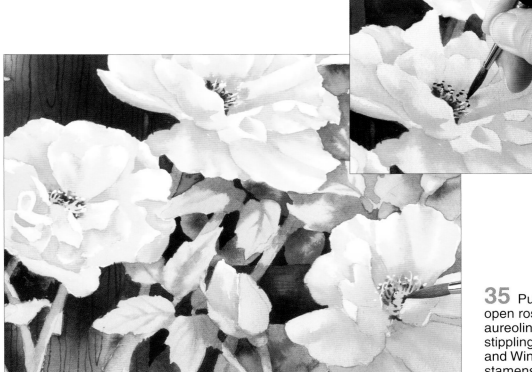

35 Push the middles of the open roses back by painting pure aureolin over the stamens, then stippling a mix of perylene maroon and Winsor violet on the ends of the stamens (see inset).

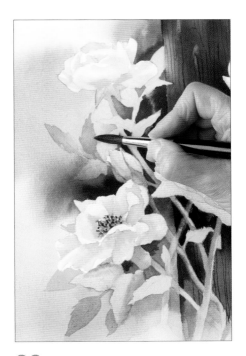

36 Use the size 8 brush to paint in some freehand leaves on the left-hand side of the painting using dilute helio green.

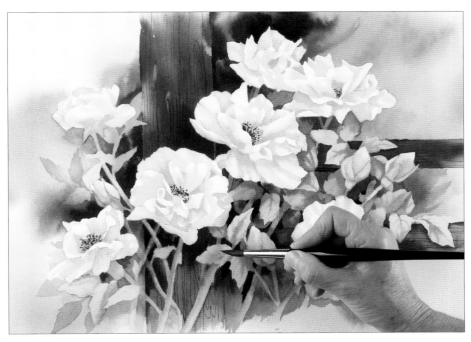

37 Push some of the foliage back with glazes of helio turquoise. Use the same technique to add cast shadows on the foreground leaves.

Overleaf

The finished painting.

21

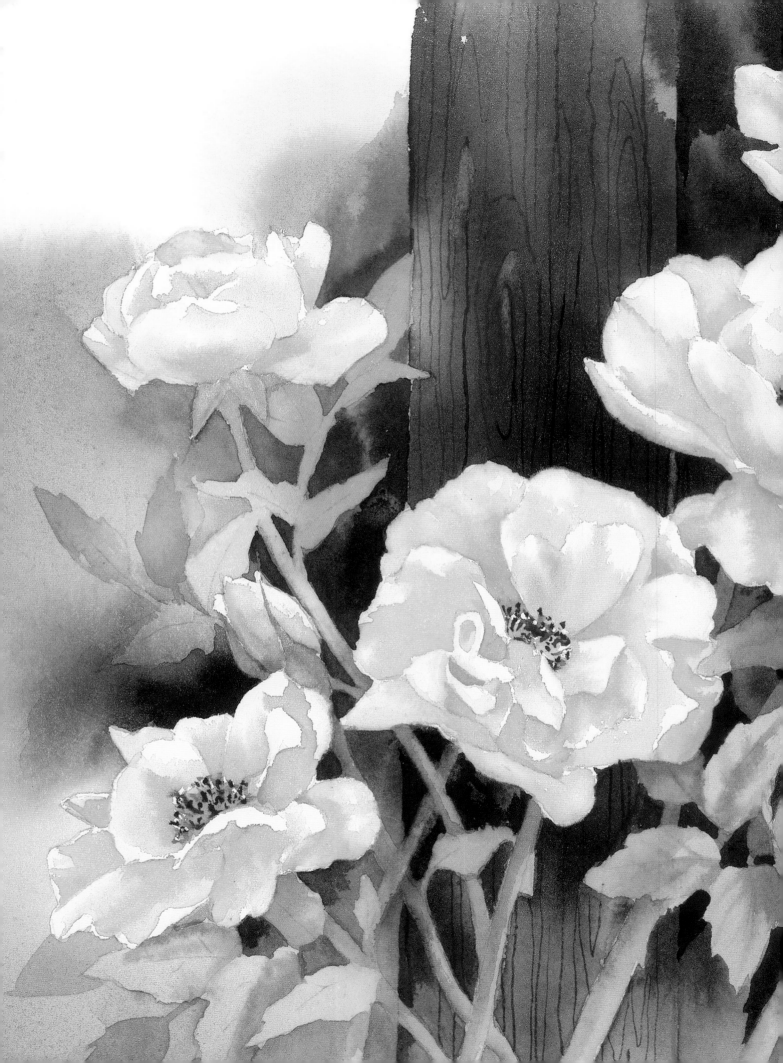

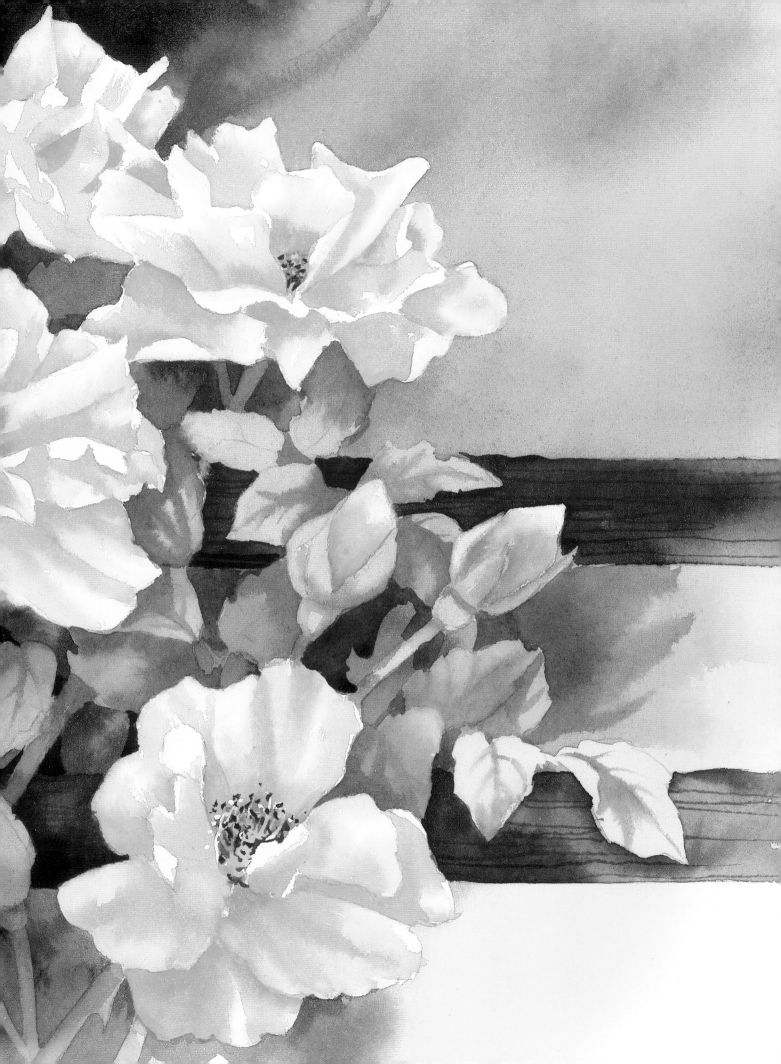

Red Roses

Using a different shape in the background – in this case, a ring – can create interest without overwhelming the roses. Because the roses used here are quite a dainty variety, this works very well.

The red is vibrant against the white of the paper. Mixing opera rose with Winsor red lifts the finished colour and stops it drying flat, as pure reds often do. I have left some areas of pure white paper showing through in the highlights to prevent the roses looking heavy.

You will need

300gsm (140lb) Not watercolour paper, 38 x 56cm (15 x 22in)

Colours: aureolin, May green, viridian, helio turquoise, Winsor red, Winsor violet, opera rose, quinacridone gold, perylene maroon, helio green, indanthrene blue, brilliant red violet

Brushes: size 7 round, size 4 round, size 8 round, size 6 round, size 1 round

Masking fluid and old brush

Eraser

Fine felt-tip pen: permanent black

Pair of compasses

Kitchen paper

Paper stretcher

1 Transfer the image as described on page 9, then dampen your paper thoroughly before mounting it on the paper stretcher. Once dry, apply masking fluid with an old brush inside the pencil lines on the rose blooms.

2 Once dry, prepare aureolin, May green and viridian. Use clean water to wet inside the inner circle using the size 7 round.

3 Use the size 7 round to drop in a little aureolin, working it into the background.

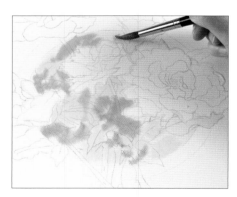

4 Drop in May green over the same areas wet-into-wet.

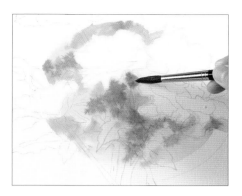

5 While the paint is still wet, work in a little viridian.

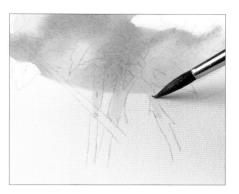

6 Tilt the board and encourage the colours to blend, then place it flat and use the brush to draw the wet paint down the stems that overlap the border. Allow to dry.

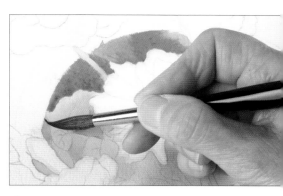

7 Starting at the top, wet the background in the circle. Working carefully around the foreground areas, paint the negative shapes behind the leaves and stems using a mix of helio turquoise and viridian.

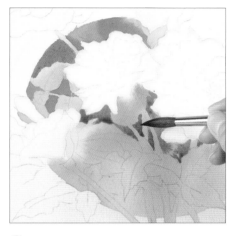

8 Wet the central areas of the background and repeat the process before continuing over the rest of the background.

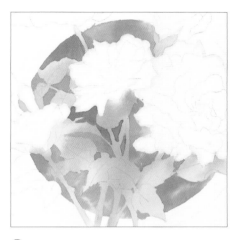

9 Draw a dilute mix down the stems and leave the painting to dry.

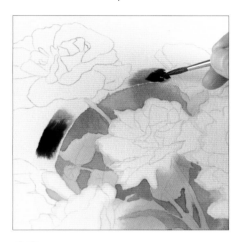

10 Dampen the top sections of the circle with clean water, then use the size 4 round to drop in Winsor red and Winsor violet wet-in-wet to create a variegated effect.

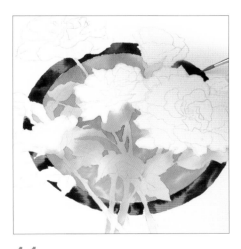

11 Work the rest of the way round the circle, then allow to dry.

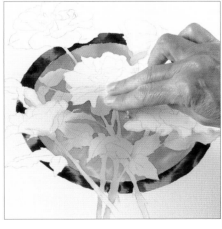

12 Use a clean finger to rub away the masking fluid round the edges of the roses.

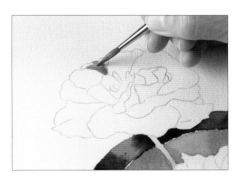

13 Starting with the flower at the top left, wet non-adjacent petals one by one with the size 8 round. Drop in Winsor red in the recesses using the size 4 round. Using the paint still on the brush, draw in excess paint down the sides.

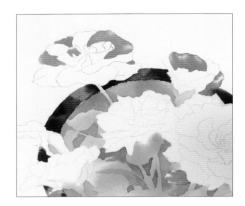

14 Continue working over the other petals with Winsor red and opera rose, dropping the colours in wet-in-wet.

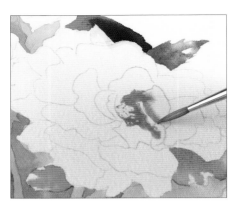

15 Work the centre of the rose on the right with quinacridone gold and Winsor red. Allow to dry.

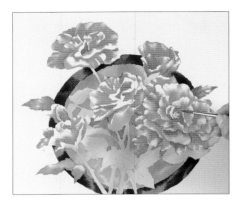

16 Work the remaining petals across the painting with Winsor red and opera rose. Work the leaves with a mix of helio turquoise and viridian, dropping in a darker mix of quinacridone gold and viridian.

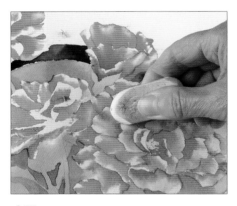

17 Allow the painting to dry, then use an eraser to knockback the pencil marks without removing the masking fluid in the centre.

18 Strengthen the centre of the open rose using the size 6 round and perylene maroon.

19 Begin to develop the background by using negative painting to bring the centre out. Use the size 8 round to wet areas, then use the size 4 to apply a mix of helio green and indanthrene blue.

20 Mix Winsor red with opera rose and build up the colour in the recesses of the open rose with the size 4 round. Bleed the paint out towards the edges of the petals.

21 Deepen the red on the other flowers in the same way, switching to the size 6 round for larger petals.

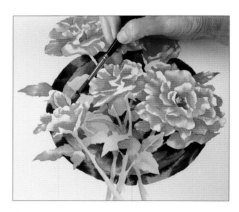

22 Strengthen the greens of the foliage with the size 6 round and a mix of quinacridone gold and helio green.

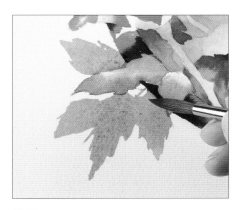

23 Add in some freehand leaf silhouettes outside the ring on the lower left with helio turquoise, then drop in Winsor violet wet-in-wet.

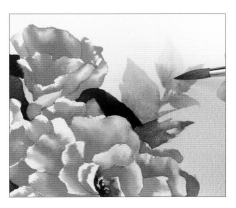

24 Balance the silhouettes by painting some more on the upper left, using the same colours.

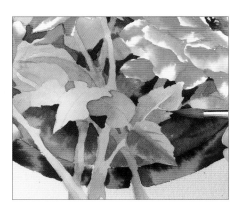

25 Detail the central leaves with size 6 round and the green mix of quinacridone gold and helio green, bringing out some of the veining with negative painting.

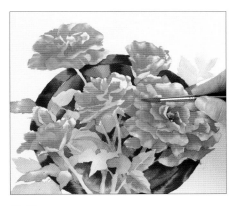

26 Glaze out a few of the stark white areas on the flowers with a very dilute mix of Winsor red and opera rose.

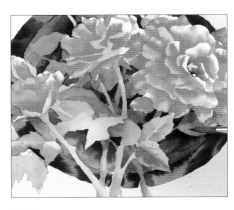

27 Use pure helio turquoise to glaze the rearmost leaves in the background, bringing the stems and foreground foliage forward.

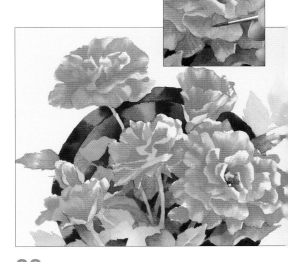

28 Use the size 1 round to add subtle veining to the petals of the main flower (see inset), drawing very fine lines from the centre to the edges. Repeat on the other flowers.

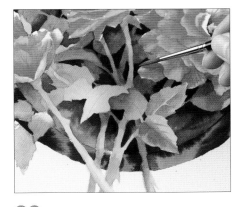

29 Reinstate the darks in the gaps between the stems with the size 1 round and a mix of Winsor violet and viridian.

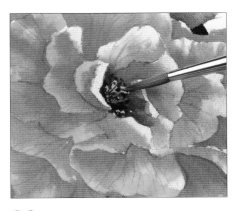

30 Remove the masking fluid from the flower centre and add some dark touches to the stamens with a mix of perylene maroon and Winsor violet.

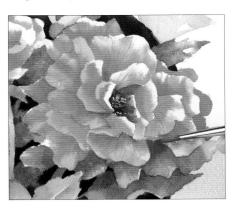

31 Glaze the petals of the main flower with brilliant red violet, applying it to the recesses and blending it away with clean water.

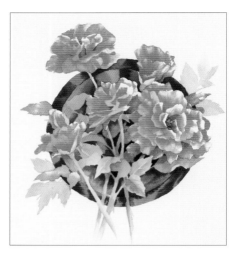

32 Switch to the size 4 round and use helio turquoise to add some more silhouetted leaves on the upper right, outside the background ring. Drop in Winsor violet wet-in-wet to vary the colour.

33 Still using the size 4 round, use perylene maroon to add the deepest shades in the recesses of the flowers.

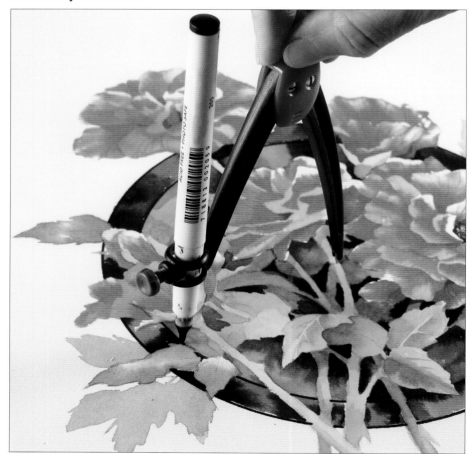

35 Allow the ink to dry, then make any final tweaks that you feel necessary, such as strengthening the colour in the flowers by glazing them with dilute versions of the earlier mixes.

34 Allow the painting to dry, then use a pair of compasses with a fine permanent felt-tip pen to add bold outlines on the inside and outside of the circle, being careful not to go over the paint.

Opposite

*The finished painting,
reduced in size.*

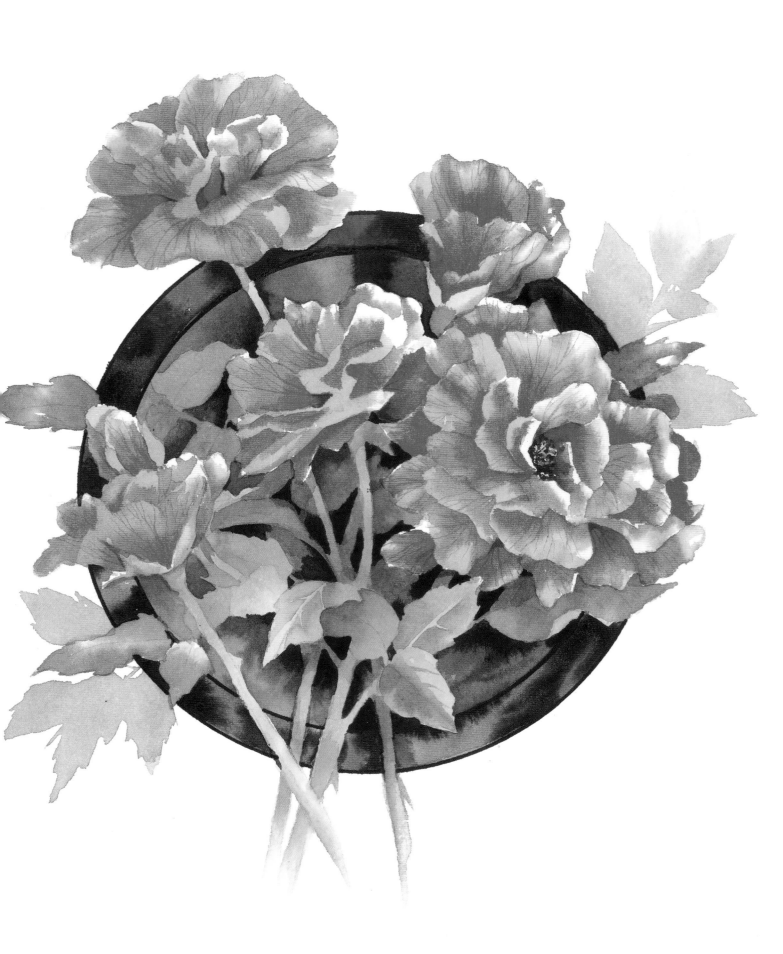

Maigold

This demonstration portrays a different kind of lighting which makes the colour very rich and vibrant. Do not be mean with your paint on this one: mix up plenty of good rich colour so that it leaves the brush easily when you touch the damp paper. Once you have mastered this technique you will find it invaluable for so many flowers. I used many of the same techniques in the painting on pages 4 and 5.

You will need

300gsm (140lb) Not watercolour paper, 56 x 38cm (22 x 15in)

Colours: opera rose, brilliant blue violet, aureolin, quinacridone gold, May green, Winsor red, helio green, indanthrene blue, Winsor violet, brilliant red violet, perylene maroon

Brushes: size 20 round, size 8 round, size 6 round, 5mm (¼in) flat, size 4 round, size 7 round

Masking fluid and old brush

Eraser

Spray bottle

Kitchen paper

Paper stretcher

1 Transfer the tracing to your paper following the directions on page 9, then wet and stretch your paper on the paper stretcher. Once dry, use an old brush to apply masking fluid as shown.

2 Use a size 20 round to wet the background with clean water, working right up to the edges of the masking fluid. Prepare your palette with opera rose, brilliant blue violet, aureolin, quinacridone gold and May green.

3 While the paper is wet, add opera rose to the background using bold strokes of the size 20 round.

4 Working wet-in-wet, drop in brilliant blue violet.

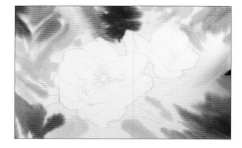

5 Working quickly, clean your brush and drop in areas of aureolin.

6 Still working wet-in-wet, drop in quinacridone gold.

7 Working quickly, drop in May green near the flowers, to establish the basis for the foreground leaves.

8 Pick up the board and tilt it gently to encourage the colours to blend together.

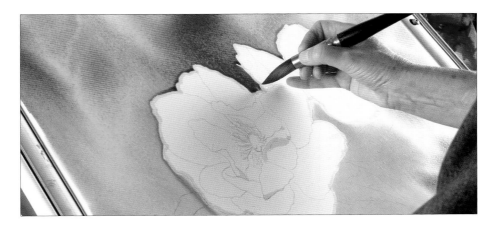

9 Use a clean damp size 20 brush to gently pick up any excess paint that gathers and forms beads. Lay the painting flat and allow it to dry completely before continuing.

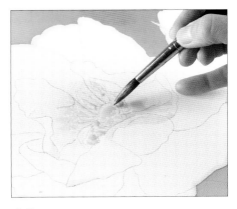

10 Switch to the size 8 round brush and lay in clean water over the centre of the open flower. Use the tip of the brush with aureolin to drop in a deeper tone in order to accentuate the stamens.

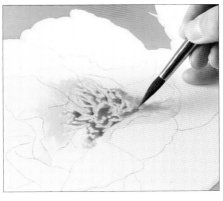

11 Drop in an orange mix of quinacridone gold and opera rose over the masking fluid, wet-in-wet.

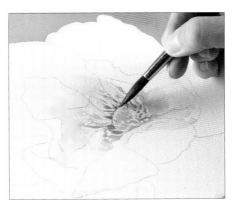

12 Paint a circle of Winsor red around the stamens, then allow the paint to dry completely.

13 Use the spray bottle to lightly wet the background while shielding the flower with your hand, then with a large brush, gently join the droplets together.

Tip

Using a brush to re-wet an area can disturb any paint in that area. A spray bottle is a great way of re-wetting areas evenly, without disturbing the paint.

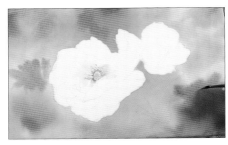

14 Once the background is wet, drop in areas of opera rose with the size 6 round.

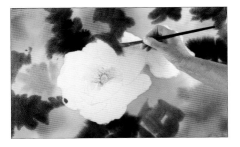

15 Working wet-in-wet, drop in helio green to establish the darker areas of the background foliage.

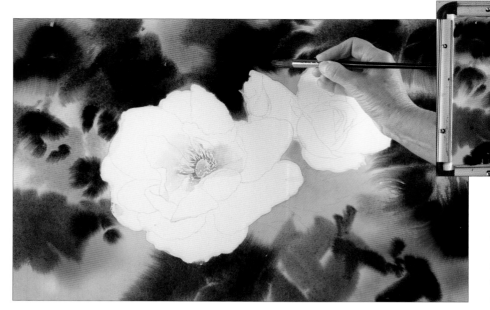

16 Still working wet-in-wet with the size 6 round brush, drop in indanthrene blue and then Winsor violet (see inset) around the flowers to develop and vary the hues in the areas of shade.

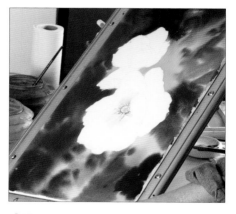

17 Tip and tilt the board once again to blend the colours together.

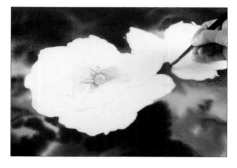

18 Use the size 6 brush to add in final areas of shade in the areas very close to the flowers themselves. Allow the painting to dry thoroughly.

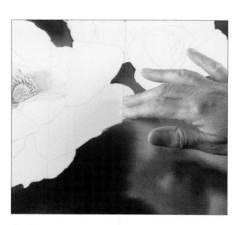

19 Rub away the masking fluid from the edges of the petals using a clean finger.

20 Soften any hard edges this reveals with a damp 5mm (¼in) flat brush and a gentle scrubbing motion.

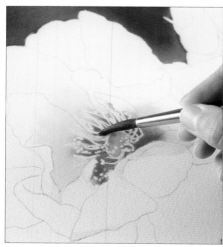

21 Use the size 8 round to wet the centre of the open flower, then drop in quinacridone gold.

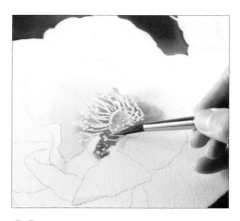

22 Drop in a little opera rose wet-in-wet and allow to dry.

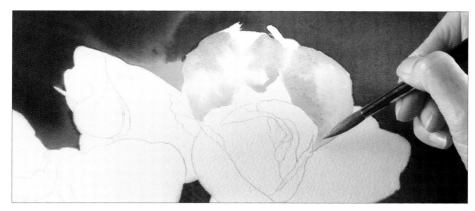

23 Switch to the size 8 round and separate the petals on the right-hand flower by wetting the largest petal and dropping in touches of pure opera rose in the shaded areas. Add in a little aureolin to vary the hue.

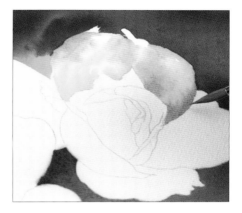

24 Shade the petal by dropping in touches of Winsor violet on the right-hand side.

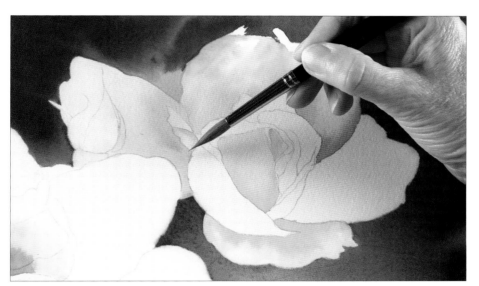

25 Continue to paint the other petals on the right-hand flower in the same way, leaving out the Winsor violet shading in the central petals to keep them lighter. Work non-adjacent petals to avoid them bleeding into one another.

26 Once the first set of petals are dry, work the remaining petals on the bloom and drop in touches of opera rose as a glaze.

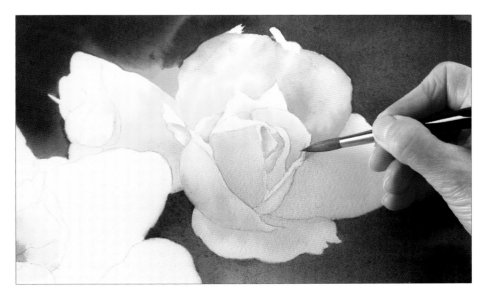

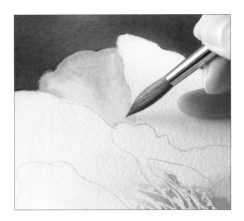

27 Start to paint the open flower, beginning with the small petal at the very back. Use the size 8 round to wet each one with aureolin, then load your brush with opera rose. Pick up the excess and draw the colour in from the edges.

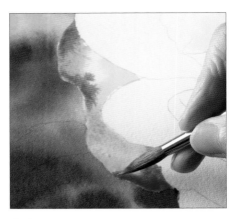

28 Paint the petals in shade on the lower left of the open flower in the same way, then drop in Winsor violet to add shading. Tip the board to blend the colours.

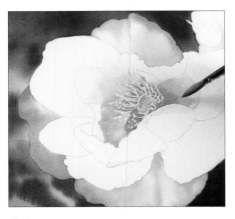

29 Work the final petal at the back, then glaze the centre again with aureolin, dropping in opera rose to vary the hue. Allow the painting to dry completely.

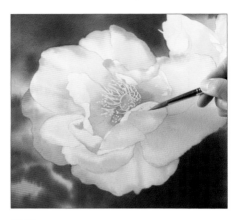

30 Gradually paint in the remaining petals with aureolin worked outwards from the centre of the rose, and opera rose blended in wet-in-wet from the edges.

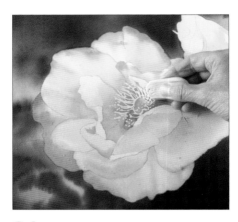

31 Once completely dry, use an eraser to remove the remaining masking fluid and pencil lines.

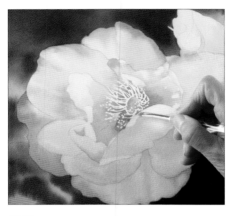

32 Soften any hard edges that this reveals with small scrubbing movements of a damp 5mm (¼in) flat, then lift out highlights across the petals in the same way.

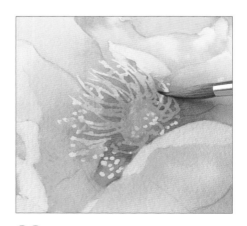

33 Use the size 6 round to paint the stamens with quinacridone gold, working in aureolin at the tips.

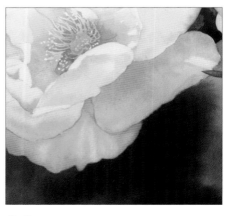

34 Still working on the open flower, wet and glaze the petals at the bottom with brilliant red violet, adding opera rose wet-in-wet.

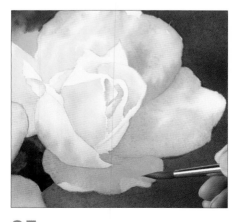

35 Swap to the right-hand flower, glazing the lower petals in the same way. Pay attention to how the light falls to get convincing shading.

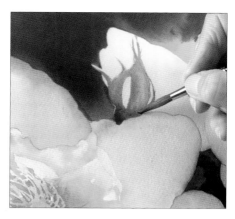

36 Use the tip of the brush to paint in the bud using May green, then work helio green in wet-in-wet for shading.

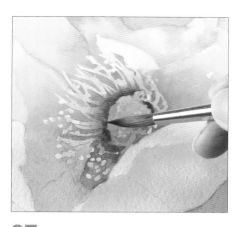

37 Swap to the size 4 round and use perylene maroon to darken the stamen centre of the open flower.

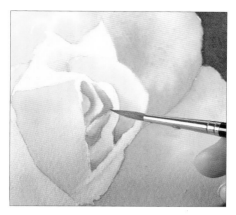

38 Detail the deep shadows on the closed flower with a mix of opera rose and Winsor red, applied with the tip of the size 4 round.

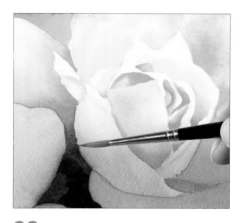

39 Add the deepest shadows with brilliant red violet.

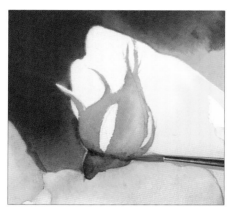

40 Shade the bud with the size 4 round and a mix of helio green and Winsor violet.

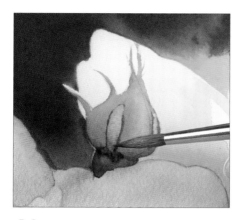

41 Paint the enclosed petals with opera rose, suggesting shading with quinacridone gold added wet-in-wet.

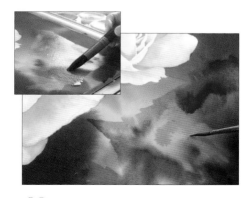

42 Begin to suggest two leaves in the background foliage at the bottom right. Wet the background behind the leaves with the size 20 round (see inset), then drop in a May green and helio green mix with the size 6 round, adding opera rose wet-in-wet.

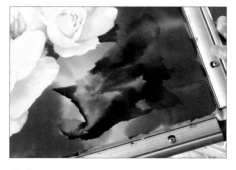

43 While the area is still wet, drop in Winsor violet, then encourage the colours to blend by tilting the board. Note how negative painting is used to suggest the leaves.

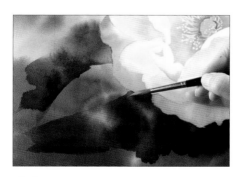

44 Bring out the third background leaf on the left with the same mixes and negative painting technique.

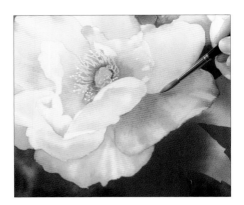

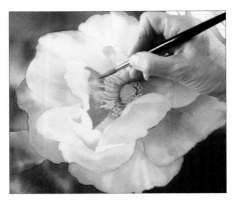

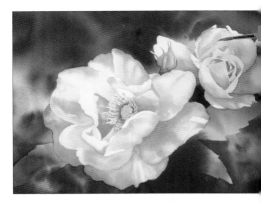

45 Wet the large lower petal on the main flower using the size 6 round, and reinstate the shadow areas with a mix of opera rose and brilliant red violet.

46 Using a mix of quinacridone gold and opera rose, reinstate the shading in the centre of the open rose. Use the tip of the brush in order to ensure that you do not cover the stamens.

47 Build up the tonal contrast with the two mixes, reinstating the areas of shadow on both flowers, and glazing the highlight areas.

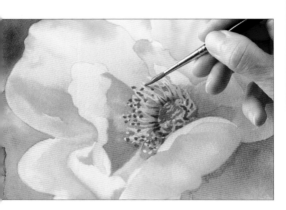

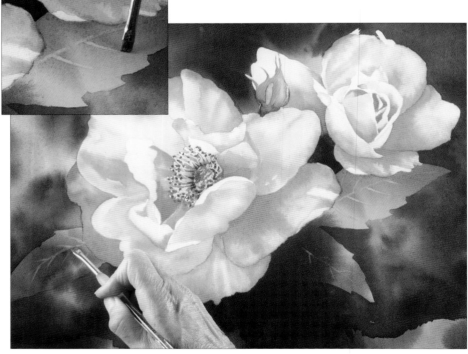

48 Bring out the stamens in the centre of the open flower with a mix of perylene maroon and a little quinacridone gold. Use the size 4 round and a stippling motion to apply the paint for a textural effect.

49 Dampen the 5mm (¼in) flat to lift out veins on the three leaves, gently wetting and moving the paint with the blade of the brush (see inset).

50 Wet the areas between the veins of the rightmost leaf with the size 6 round. Drop in a mix of helio green and May green, blending it out to shade and accentuate the veins.

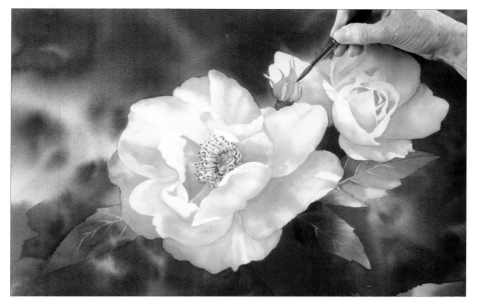

51 Paint the other leaves in the same way, then repeat the process on the rosebud near the centre.

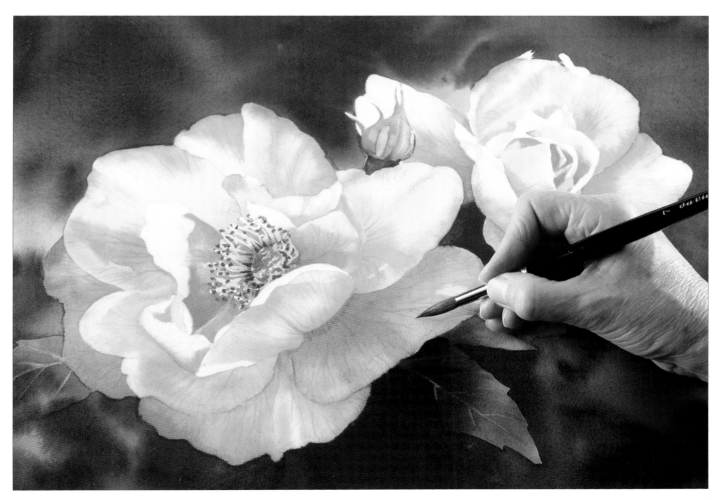

52 Vein the petals with very dilute brilliant red violet, drawing the tip of the size 7 round out from the centre to the edges of the petals.

Overleaf
The finished painting.

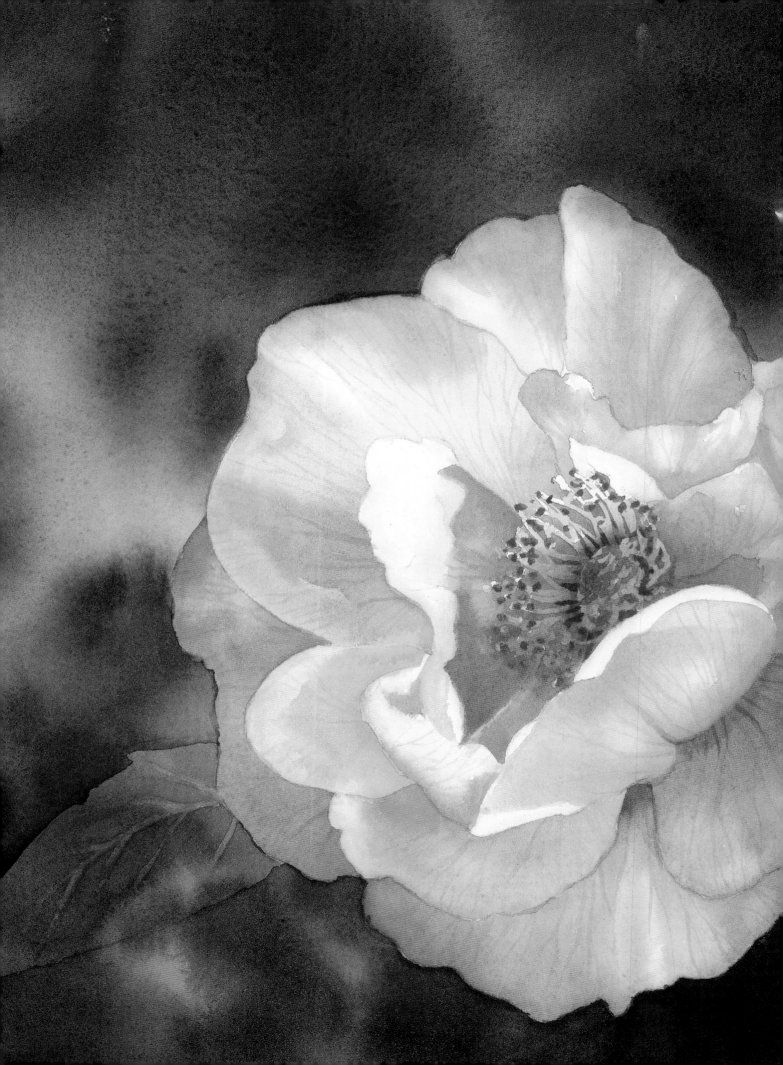

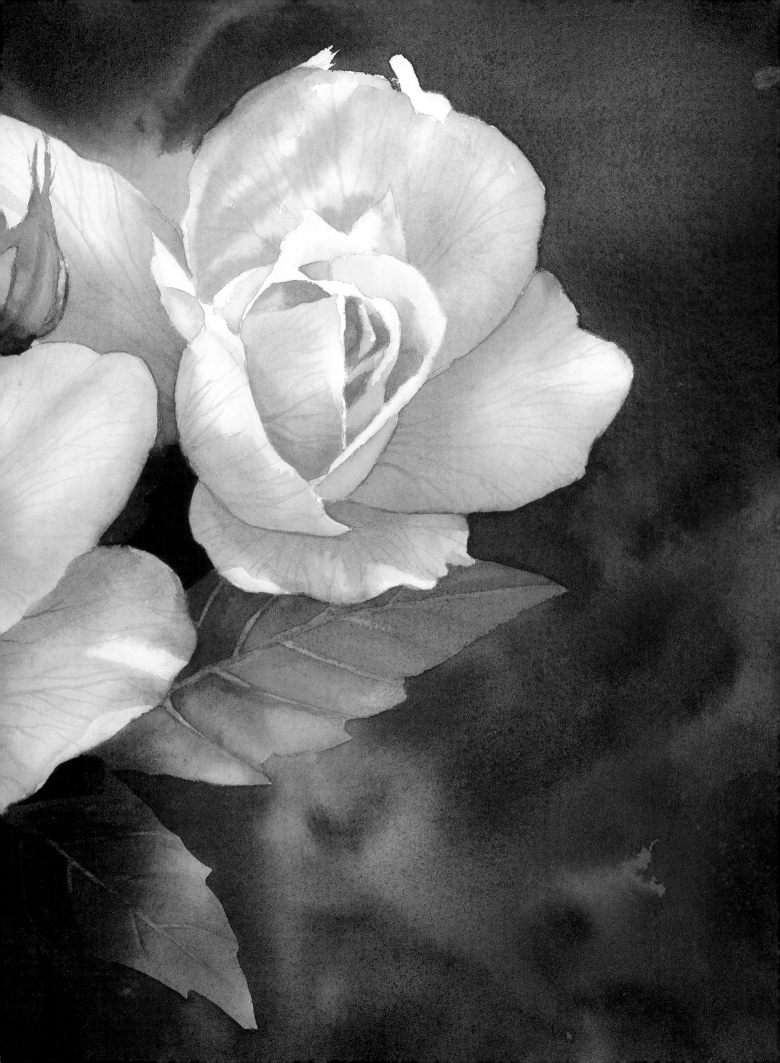

White Roses

White roses are joy to do, and this Iceberg variety is no exception. Because there are no colours to complement, you are free to use your imagination and experiment on the background. You can bounce the colour you use on to the petals to unite the painting to create atmosphere. Use more blues for a cooler painting and more reds or pinks for a warmer effect.

Alternatively, you could combine them with another flower, as in the finished painting of white roses and lavender on page 48.

You will need

300gsm (140lb) Not watercolour paper, 56 x 38cm (22 x 15in)

Colours: cobalt blue, opera rose, Winsor violet, May green, helio green, Paris blue, quinacridone gold, indanthrene blue, aureolin, brilliant red violet, perylene maroon, phthalo turquoise

Brushes: size 20 round, size 8 round, size 1 round, 5mm (¼in) flat, size 4 round

Masking fluid and old brush

Eraser

Kitchen paper

Paper stretcher

1 Stretch your paper on the paper stretcher after transferring the image, as described on page 9. Mask the stamen area with a stippling action and an old brush, then apply masking fluid inside the pencil lines on the edges of the flowers to isolate them.

2 Once the masking fluid is completely dry, use the size 20 round to wet the background with clean water, working up to the edges of the flowers.

3 Still using the size 20 round, drop in areas of cobalt blue, then add touches of opera rose.

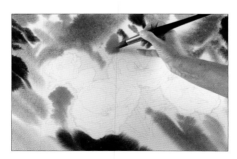

4 Working wet-into-wet, add Winsor violet followed by small areas of May green.

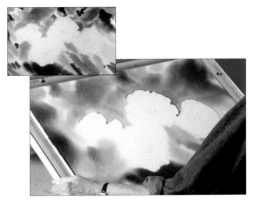

5 Add helio green (see inset) before tipping and tilting the board to blend the colours together.

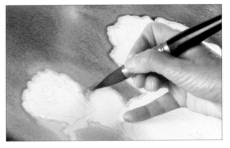

6 Clean and dry the size 20 round and use the tip to absorb any beads of collected paint. Lie the board flat and leave it to dry completely.

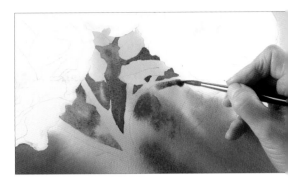

7 Using a size 8 round brush, wet the background below the flowers, then use a mix of helio green and Paris blue to suggest the stems using negative painting.

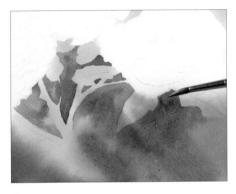

8 Continue painting negative shapes to bring the foreground stems and leaves forward, switching to cobalt blue as you work to the bottom right and get further from the flower.

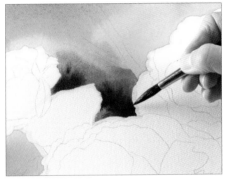

9 Wet the area at the top left of the flowers, then drop in helio green, quinacridone gold and indanthrene blue, working each colour in wet-in-wet.

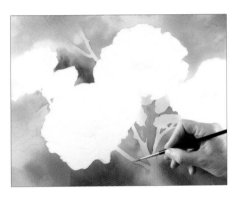

10 Continue working around the flowers using the same colours wet-in-wet to build up a variegated background around the stems. Work gradually, and switch to the size 1 round for any hard-to-reach areas.

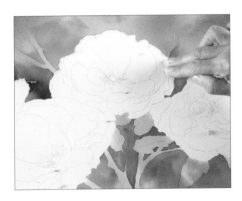

11 Use a clean finger to rub away the masking fluid from the edges of the petals. Leave the masking fluid in place on the stamens.

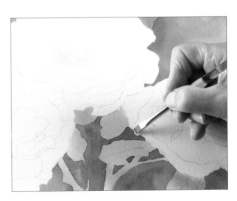

12 Use gentle, tight, scrubbing motions of the 5mm (¼in) flat brush and clean water to lift the paint and soften any hard edges.

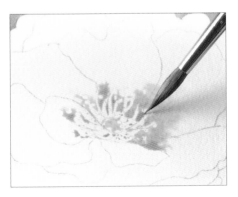

13 Wet around and inside the stamen area of the central flower, then drop in opera rose using the size 4 round.

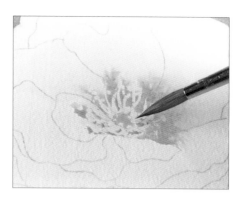

14 Add aureolin to create variety in the centre and tilt the board to encourage the colours to bleed into one another.

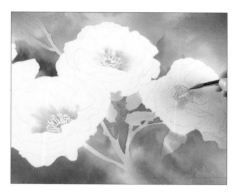

15 Paint the centres of the other open flowers in the same way.

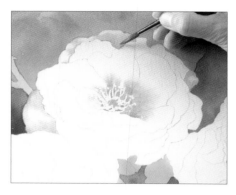

16 Wet the petals at the back of the central flower with the size 6 round, then drop in a lilac mix of cobalt blue and brilliant red violet. Draw the paint outwards from the recesses, fading it to the edges.

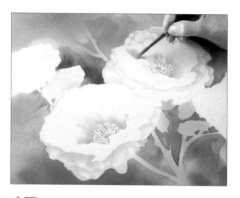

17 Continue painting the outer petals of the two central flowers, bleeding the colour out to nothing to preserve the white of the paper as highlights.

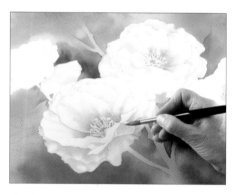

18 Work the lilac mix into the recesses of the two central flowers, drawing the paint out with clean water and encouraging it to diffuse.

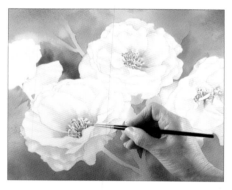

19 With the same technique and lilac mix, develop the tone on the right-hand flower. Use a size 4 round to re-wet the stamens and reinforce the colour with quinacridone gold, adding perylene maroon wet-in-wet.

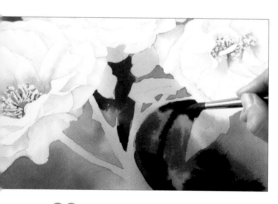

20 Switch to the size 8 round and re-wet the background on the lower right. Drop in helio green, varying the colour with Winsor violet for rich, dark tones. Develop the background, leaving some areas uncovered as shown.

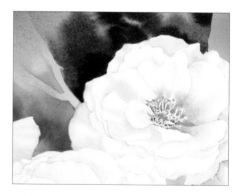

21 Develop the tonal contrast in the background above the top flower using the same colours and techniques.

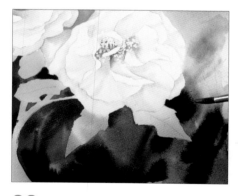

22 Wet the extreme bottom-right area and drop in the same dark tones. Pick up and tilt the board to blend the colours together.

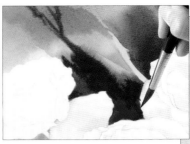

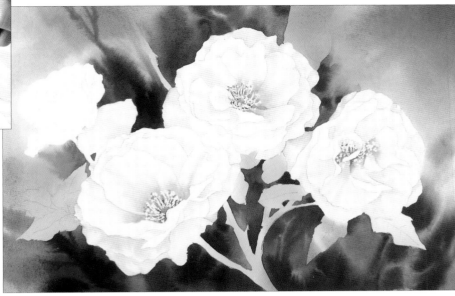

23 Use the same colours to develop the upper left, drawing the paint out into branch-like forms (see inset), then switch down to the bottom of the painting and develop the background there. Allow the painting to dry completely.

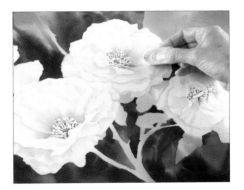

24 Remove the masking fluid from the stamens and soften the pencil lines on the open flower using a clean eraser.

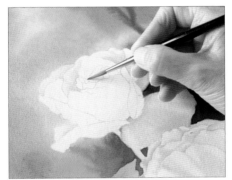

25 Wet non-adjacent petals on the closed rose with the size 4 round, and use a mix of brilliant red violet and cobalt blue to paint the recesses, drawing the paint out to leave clean paper for the highlights.

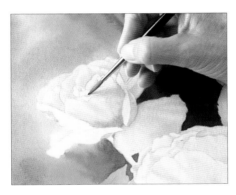

26 Using a slightly less dilute mix for the darker tones, continue to paint the closed flower.

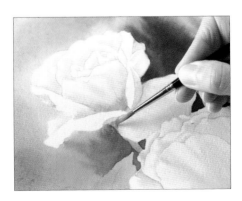

27 Paint in the stem with a mix of helio green and May green.

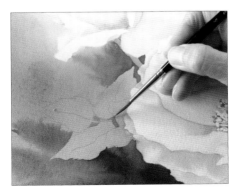

28 Use negative painting with the same mix to bring out the leaves below the closed flower.

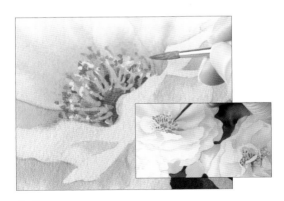

29 Paint the stamens of the left-hand flower with a size 4 round and an aureolin and opera rose mix, then paint the stamens of the other two flowers (see inset).

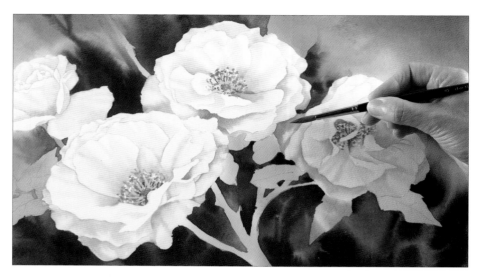

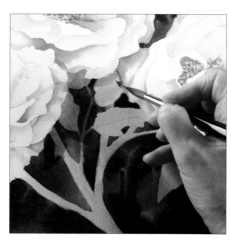

30 Still using the size 4 round, develop the tonal contrast by deepening the shadows of the open roses with additional washes of brilliant red violet and cobalt blue. Wet particularly large petals with clean water using the size 8 round before applying the paint.

31 Soften the hard edges on the stems beneath the open flowers with the 5mm (¼in) flat brush, then glaze them with a mix of helio green and quinacridone gold, applying the paint with the size 8 round.

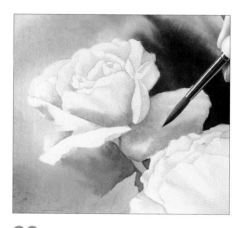

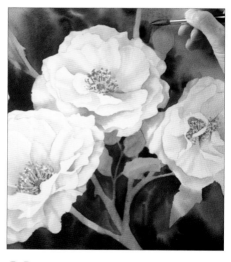

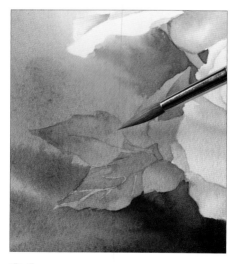

32 Deepen the shades in the closed flower with the same mixes and brush as for the open flowers.

33 Use indanthrene blue to deepen the background shadows, wetting the areas up the stems and dropping the paint in wet-in-wet.

34 Use the helio green and quinacridone gold mix to develop the leaves on the left-hand side of the picture, using negative painting to suggest the veins.

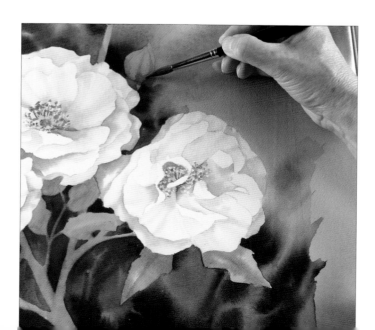

35 Use the same mix to develop the leaves on the bottom right and the bud and stems on the top right.

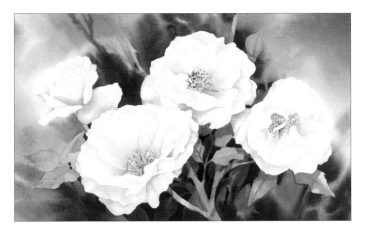

36 Continue to knock back the shadows in the foliage using glazes of an indanthrene blue and Winsor violet mix, using the colour to suggest new leaves and stems with negative painting.

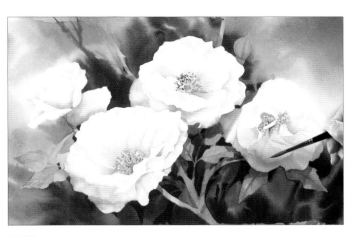

37 Knock back the flowers very slightly with very dilute glazes of a phthalo turquoise and Winsor violet mix at the edges, softening them away with clean water.

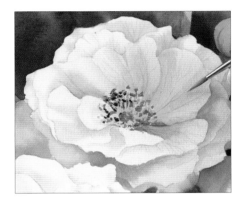

38 Allow the paint to dry completely, then use the tip of the size 4 round to draw fine veins on the topmost open rose with a mix of brilliant red violet and cobalt blue.

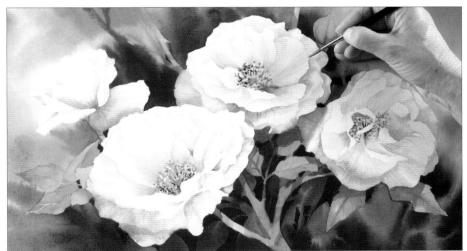

39 Continue to paint the fine veins over the other petals, radiating them out from the centres of the flowers to the edges of the petals. Concentrate on the darker petals, leaving the highlights clean to represent the sunlight bleaching out the detail.

40 Soften any remaining hard lines across the painting with a gentle scrubbing motion of the 5mm (¼in) flat and clean water.

41 Glaze the foreground foliage with very dilute aureolin in order to warm it slightly, then allow the painting to dry to finish.

Overleaf
The finished painting.

45

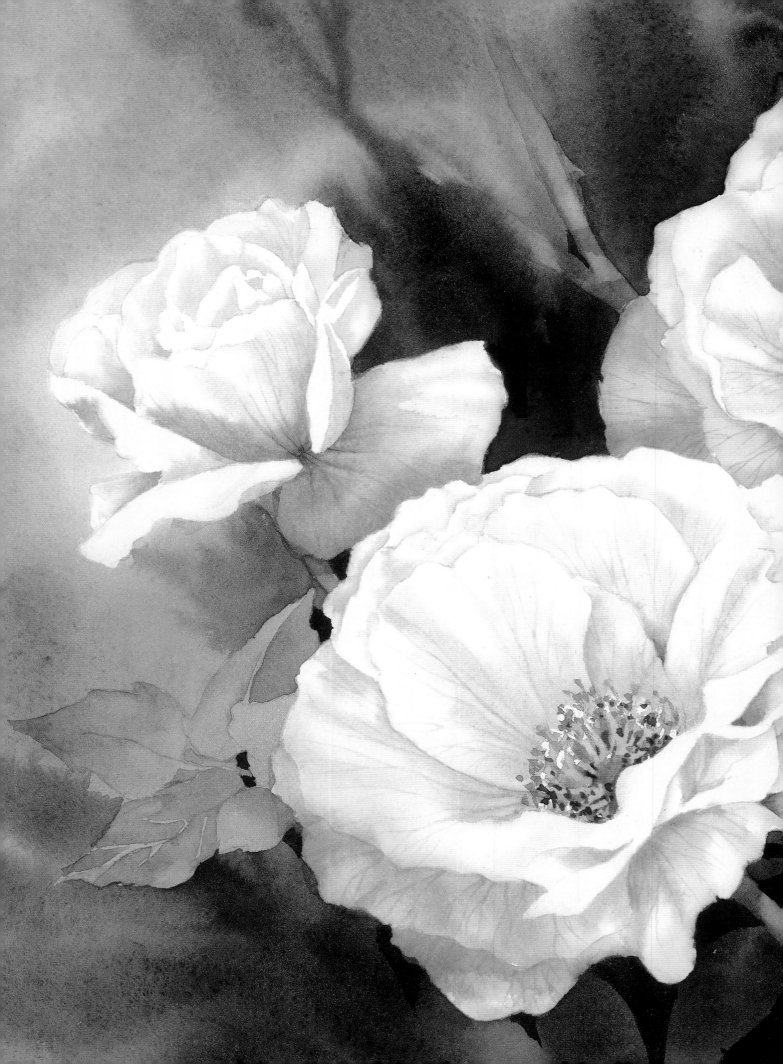

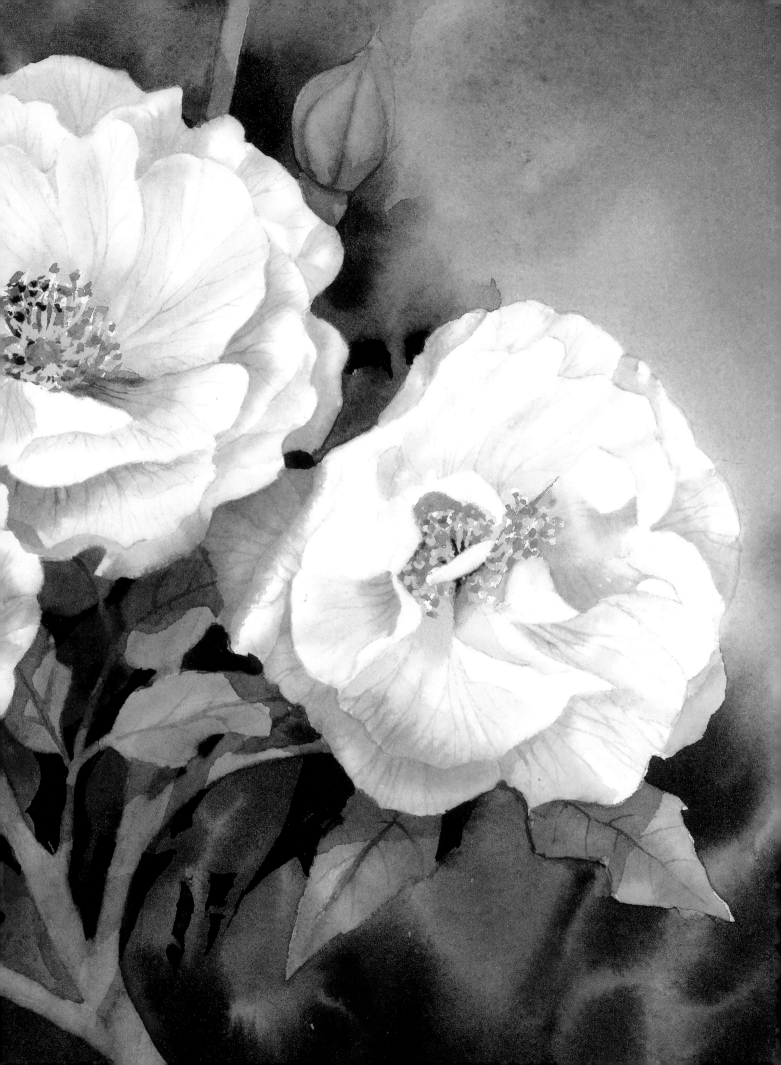

Index

White Roses and Lavender
53 x 35.5 (20¾ x 14in)

This painting uses many of the same effects as the White Roses project on pages 40–47, but uses more blues for a cool effect. I have also added lavender to the composition, to set off the roses and give some movement.

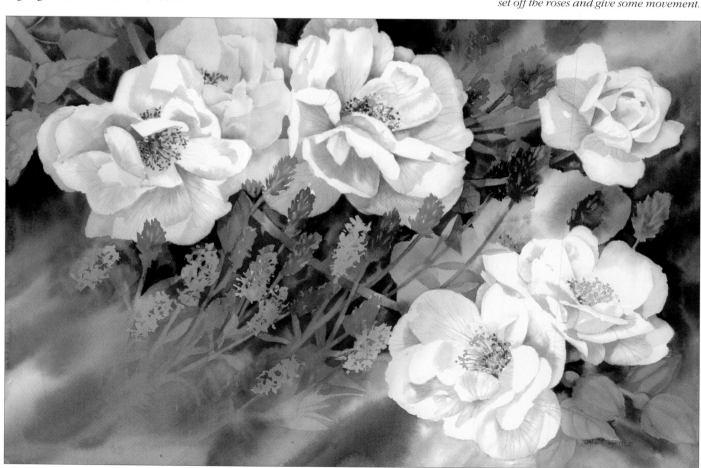